THE GREAT DETECTIVE
SHERLOCK
HOLMES
— THE DYING DETECTIVE —

THE GREAT DETECTIVE
SHERLOCK HOLMES
— THE DYING DETECTIVE —

The Black Corpse

With a **chubby** patrol officer named Hippo leading the way, Scotland Yard police detectives Gordon "Gorilla" Riller and Carlson Fox walked *briskly* through a dark and **damp** alley to the front of a rickety wooden shack.

"This is the shack," said Hippo timidly.

"Where are the people who found the dead bodies?" asked Gorilla.

Hippo took an uneasy gulp before uttering in a stammer, "They're…probably gone already…"

chubby (形) 肥胖的、胖墩墩的　　briskly (副) 匆匆地　　damp (形) 潮濕的、濕漉漉的　　rickety (形) 搖搖欲墜的
shack (名) 簡陋小屋　　timidly (副) 膽怯地、戰戰兢兢地　　stammer (名) 結結巴巴地說話

Fox cringed his eyebrows and **huffed irritably**, "How could you let them go? You should know better that they must be questioned."

"Yes, but..." nodded Hippo nervously. "They were too *spooked* so..."

"Forget it," said Gorilla as he waved his hand in annoyance. "Just open the door so we can go in and inspect the body."

Hippo looked terrified upon hearing those words. Not only did he not step forward to open the door, he even took a **frightful** step backwards before pointing at the door apprehensively, "The door...is unlocked but..."

Thinking that Hippo must be scared of dead bodies, Gorilla **scoffed** at Hippo, "What a *coward*! How could you even call yourself a policeman if you're so **queasy** about the sight of dead bodies?"

"No, I..."

"Just admit that you're a coward!"

huff(ed) (動) 發怒、氣沖沖　　irritably (副) 煩躁地、性急地　　spooked (形) 驚慌的
frightful (形) 惶惶恐恐的　　apprehensively (副) 憂慮地、惴惴不安地　　scoff(ed) (動) 嘲諷、譏笑
coward (名) 膽小鬼、懦夫　　queasy (形) 覺得噁心的、心神不定的

growled Gorilla *intimidatingly* at Hippo.

"But sir…"

"But what? Shut your cowardly face and get out of the way!" Gorilla shot a glare at Hippo before pushing the door open with a loud bang.

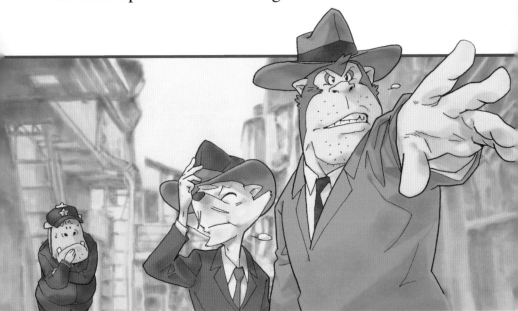

A **stifling odour** that smelled like **swill** came rushing out in an instant. Gorilla frantically covered his nose with his hand and said to Fox, "Ugh! It smells really nasty in here! No wonder that coward refuses to come in."

growl(ed) (動) 大聲喝道、咆哮　　intimidatingly (副) 威嚇地
stifling (形) 熱得令人窒息的、悶熱的　　odour (名) 氣味、臭味　　swill (名) 餿水、廚餘

"But this isn't the putrid scent of a dead body. It's just the stuffy smell of awful ventilation mixed with humidity and perspiration. Perhaps the tenant of this shack never bothers to do any cleaning," said Fox, also covering his nose with his hand.

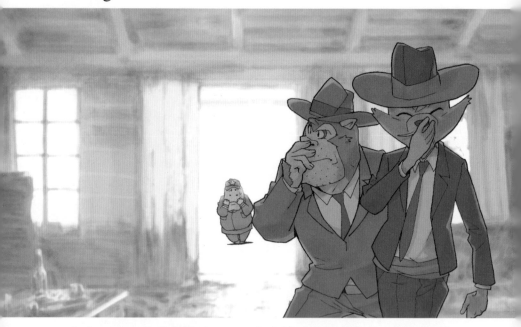

A beam of daylight **emanating from** the doorway shone directly onto a body lying on the floor. Without a doubt, this was the victim that brought Hippo to notify Scotland Yard.

Fox knelt down next to the dead body and took a look

putrid (形) 腐臭的、腐爛的　　stuffy (形) 空氣不流通的、悶熱的　　ventilation (名) 通風
humidity (名) 濕氣　　perspiration (名) 汗水　　emanating (emanate) from (片語動) 放射、來自

at the victim's skin, "The skin has darkened so much that it is black."

Gorilla took a peek from behind Fox without moving closer to the dead body. He seemed to be very much disgusted by the malodour.

Fox pressed lightly on the victim's bare arm with his index finger then said, "The victim's muscle still springs back. Perhaps he is only been dead for a short time."

"Detectives, may I have a word please?" Loud cries from Hippo sounded from behind Gorilla.

Gorilla turned around only to find Hippo standing far away from the doorway. "What is it, you useless coward? Why are you speaking to us from so far away? What is wrong with you?" shouted Gorilla at Hippo.

"Please sir, I must speak with you… Please come over to me…" implored Hippo. "You need to step out of the shack right now. I'm not walking in there. We

malodour (名) 惡臭、難聞的氣味　bare (形) 露出的　spring(s) back (片語動) 彈回
implore(d) (動) 懇求、哀求

must talk outside."

"What?" Gorilla was so furious that his head was about to explode. He could not believe that such a stupid, low-ranking patrol officer would dare to summon two illustrious Scotland Yard detectives to come to him instead of the other way around. Just when Gorilla was about to lash out, Hippo began shouting towards the shack again, "Sir, the victim has probably died from **the Black Death**. It's best not to go near him!"

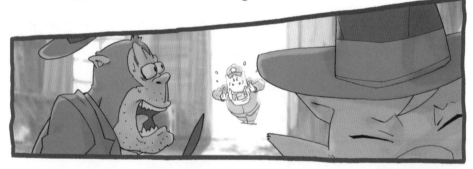

"What?" screamed Gorilla in shock.

Fox could not hear Hippo clearly so he asked Gorilla, "What was he hollering about? I could only hear 'black something'?"

"Black Death! It's the Black Death!" yelled Hippo as loud as he could.

summon (動) 召喚　illustrious (形) 鼎鼎大名的、卓越的　lash out (片語動) 痛罵、斥責
the Black Death (名) 黑死病　holler(ing) (動) 大聲叫嚷

Gorilla was so shocked by this information that he was stunned stiff for a few seconds. All of a sudden, Gorilla could hear a *mortifying shriek* echoing around him as Fox ran past Gorilla and darted out the door in a *tumble*. Only then did Gorilla follow suit and dash out of the shack in panic.

Taken aback by the sight of the two *petrified* grown men screaming like little girls, Hippo began to speak nervously as Gorilla and Fox tried to regain their **composure**, "The people who found the victim brought a doctor to the scene before they reported the discovery to the police. According to the doctor, it's likely that the victim died from the Black Death. Since the **parliament** is also conferring on the Black Death at the moment, everyone is thrown into panic and fear."

Fox's face turned completely pale upon hearing

stiff (副) 十分、非常　mortifying (形) 凄慘的、令人窘迫的　shriek (名) 尖叫
tumble (名) 跌跌撞撞　follow suit (片語) 跟着做、依樣畫葫蘆、仿效
petrified (形) 嚇呆了的　composure (名) 鎮定　parliament (名) 英國議會、國會　9

those words. His nerves had yet to be settled and his lips quivered as he spoke, "No wonder the victim's skin is so dark. Oh my goodness! It's the Black Death!"

Coming back to his senses, Gorilla hoisted Hippo up by the collar and roared, "You idiot! Why didn't you tell us earlier if you knew that the victim has died from the Black Death? Are you trying to get us killed?"

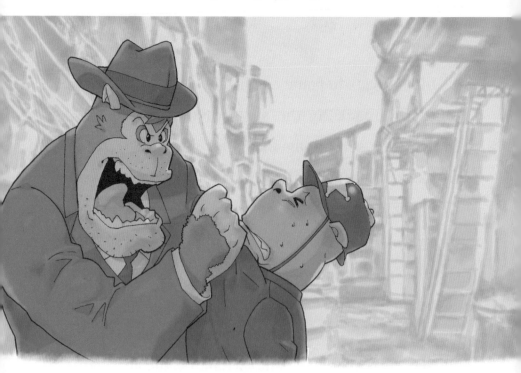

"Sir... I tried to tell you, sir... but you *barged in*

quiver(ed) (動) 發抖、顫抖 hoist(ed) (動) 舉起、升起 barge(d) in (片語動) 衝入

before I could tell you anything..." explained the terrified Hippo.

Upon hearing those words, Gorilla let out an **irritated puff of breath** before letting go of Hippo. Gorilla then began to wipe the sweat off his forehead and said with a sigh of relief to Fox, "Good thing I hated the smell so much that I didn't walk near the dead body."

Fox was so overwhelmed with fear that his face had now turned from whitewashed pale to deathly grey.

Noticing the change of colour on Fox's face, Hippo asked Fox urgently, "Sir, were you near the dead body just now?"

"Yes..." replied Fox as his lips quivered in a **frenzy**.

Hippo widened his eyes and further inquired, "Sir, did you touch the dead body?"

"Fox, did you touch the victim?" asked Gorilla worriedly.

"Let me think..." Fox placed the tip of his index finger on his lips as he rolled his eyes to

irritated (形) 煩躁的、氣惱的　　puff of breath (名) 一口氣　　frenzy (名) 瘋狂

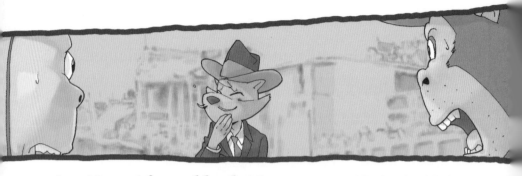

the side and jogged back his memory. "I don't think so."

"Hmmm…" Gorilla thought for a moment before asking suspiciously, "Didn't you mention earlier that the victim's muscle could spring back?"

Fox nibbled on his index finger

as he pondered for a moment before replying, "Now that you mention it, I might've said something like that, but then…"

"Oh my God!" screamed Gorilla, cutting off Fox in mid-sentence and jumping a huge step backwards. "You touched the victim's arm!"

Only then did Fox realise what was happening. He stared at his index finger and said, "Yes, I remember

jog(ged) back memory (習) 回想、喚起記憶 nibble(d) (動) 輕輕咬着
ponder(ed) (動) 沉思

now! I used my finger to press the victim's arm!"

"Oh my God!" screamed Hippo this time, also jumping a huge step backwards. "You had your finger on your lips just now and you were nibbling on it too!"

"What?" Fox let out a sharp shriek then began to **vomit** uncontrollably.

Looking at the miserable Fox, Hippo could not help but whisper in Gorilla's ear, "Sir, could your partner have contracted the Black Death?"

Those words verbalised the exact worry in Gorilla's mind. Dumbfounded by the unexpected turn of events happening before his eyes, Gorilla was at a loss and did not know how to respond to Hippo's disconcerting question.

vomit (動) 嘔吐 contract(ed) (動) 感染 verbalise(d) (動) 用言辭表達
dumbfound(ed) (動) 使驚呆 disconcerting (形) 令人困惑的、令人不安的

Cool Scientific Facts

【Infectious Disease】

The Black Death is a kind of infectious disease. Before delving into the characteristics of the Black Death, let's understand what exactly is an infectious disease.

Infectious diseases can be passed from one person (or animal) to another and spread exponentially to many others through contact with the host of a pathogen, such as bacteria, virus, or through various channels of infection, such as air, saliva, food, drinks, fleas, mites and more. Examples of infectious diseases include cholera, tuberculosis, leprosy, smallpox, typhoid fever, influenza, bubonic plague (Black Death), SARS, H7N9 bird flu among others.

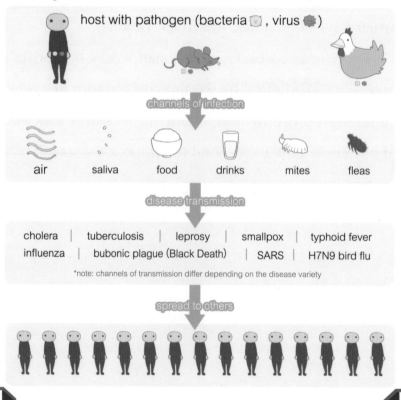

host with pathogen (bacteria , virus)

channels of infection

air saliva food drinks mites fleas

disease transmission

cholera | tuberculosis | leprosy | smallpox | typhoid fever
influenza | bubonic plague (Black Death) | SARS | H7N9 bird flu

*note: channels of transmission differ depending on the disease variety

spread to others

The Serial Killer

"Have you read this news article?" said Sherlock Holmes, his eyes fixed on the evening newspaper.

"What news article?" asked Dr. Watson.

Holmes handed the newspaper to Watson and said, "It writes that there's an outbreak of the Black Death in both Hong Kong and India. Since English commercial ships sail in and out of their ports frequently, some parliament members are concerned that those ships may be carrying the infectious disease into London."

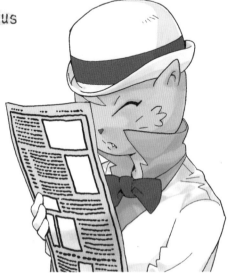

outbreak (名) 爆發 infectious disease (名) 傳染病

Watson took the newspaper then said worriedly after reading the article, "The Black Death is no joke. One third of the entire European population was wiped out from the very disease a few centuries ago."

"Yes." Holmes suddenly switched to a **cryptic** tone, "Actually, the Black Death may have spread to London already. Perhaps the government just hasn't told the public yet in order to prevent a mass panic."

"Looks like you have taken a keen interest in the Black Death. You seem to be more updated about it than I, and I'm a doctor."

Black Death

Also known as the plague, the Black Death is an infectious disease that spreads rapidly. Caused by a bacterium called Yersinia pestis, the plague is categorised into three types, namely bubonic plague (lymph node infection), pneumonic plague (lung infection) and septicemic plague (blood infection). The disease is usually spread by fleas, which pick up the bacteria from rats already infected with the disease then pass the bacteria to humans they bite. Symptoms will show within a few days after a person is infected and the mortality rate is very high, making the disease very terrifying. Also, people who are infected with septicemic plague will bleed under the skin, developing blackened patches that cover large parts of their bodies when they die. It is this ghastly appearance on the dead bodies that earns the disease its other name, the Black Death.

cryptic (形) 神秘的 take(n) a keen interest in (習) 產生濃厚的興趣 plague (名) 瘟疫
bacterium (名) 細菌 Yersinia pestis (名) 鼠疫桿菌 bubonic plague (名) 腺鼠疫
pneumonic plague (名) 肺鼠疫 septicemic plague (名) 敗血性鼠疫
flea(s) (名) 跳蚤 mortality rate (名) 死亡率 ghastly (形) 可怕的、恐怖的

"My information network links directly to senior officials in the government. Things like this reach my ears rather easily," said Holmes lightly. "Not to mention that I tend to remember anything that has to do with death."

Watson clicked his teeth in astonishment and said, "That sounds so creepy! I didn't know that you're so intrigued by death."

"Of course I am. A private detective must be interested in death in order to be good at investigating murders."

"I guess it's a shame for you that even if a death were to be discovered, the cause of death this time would be illness and not murder," teased Watson, finding Holmes's dark hobby rather horrific. However, what Watson had not expected at that moment was that a crisis triggered by the Black Death had already started flooding in quietly like a gloomy tide, and it would even threaten Holmes's life later on!

astonishment (名) 驚訝、愕然　　creepy (形) 令人毛骨悚然的、不寒而慄的、怪異的
intrigue(d) (動) 感興趣、引起好奇　　tease(d) (動) 嘲弄、取笑
gloomy (形) 陰沉的、灰暗的

All of a sudden, urgent footsteps sounded from the stairs. The two men turned their heads towards the front door as it swung open with a loud bang. Coming in through the doorway was none other than Gorilla, the well-known police detective from Scotland Yard.

"Oh my God… Oh my God! Fox just got locked up!" shouted Gorilla, heaving for breath after running up the stairs.

"What are you talking about?" Holmes and Watson were surprised by Gorilla's sudden evening visit and were all the more taken aback after hearing those words.

"Oh my God… Oh my God… Oh my God…" Perhaps Gorilla was too shaken up and too tired, he kept repeating those three words as though he was reciting a chant. As he planted his bottom on the sofa, he took out his handkerchief to wipe the sweat off his forehead.

reciting (recite) a chant (片語) 口中念念有詞

"What happened? Has Fox committed a crime or something?" asked the concerned Watson.

"No, no, no!" Gorilla shook his head with all his might. "It's the Black Death! It's all because of the Black Death!"

"The Black Death?" Watson was so **startled** by those words that he jumped out of his chair at once. "Has the Black Death really spread to London already? Is Fox infected?"

"No, no, no!" Gorilla shook his head with all his might again. "He hasn't shown any symptoms yet, but the doctors said they need to lock him up for safety reasons, so he wouldn't spread the disease to other people in case he really is infected."

Holmes rolled his eyes and corrected Gorilla, "That's called '**isolation**', not 'locking up'! The Black Death is a highly contagious disease. Isolating patients is the best way to prevent it from spreading."

startled (形) 吃驚的、受驚的　　isolation (名) 隔離
contagious (形) 傳染性的、會傳染的

Tears began to well in Gorilla's eyes as he whimpered, "Yes, you're right. The doctors said they needed to **isolate** Fox for a month to see if he shows any symptoms. I hope he isn't infected. I hope they don't have to put him **down**."

Both Holmes and Watson could not help but **drop their faces into their palms** upon hearing those words.

"Fox is not a dog with **rabies** so why would they need to put him down? Not to mention that the Black Death infection doesn't necessarily lead to death. And even if symptoms were to show, there's a chance that he would survive with proper treatment," said Watson in a half lecturing, half consoling tone.

But Gorilla was feeling **fretful** nonetheless. He blew

isolate (動) 隔離　　put down (片語動) 人道毀滅
drop their faces into their palms (習) 用手遮着臉　(表示對事情感到無奈、無言)
rabies (名) 瘋狗症、狂犬病　　fretful (形) 焦慮的、煩躁的

his nose into his handkerchief and said, "But they're isolating Fox for an entire month. It's going to scare his mother to death!"

"What do you mean?" asked Holmes.

"Fox might be this **quarrelsome pain in the neck** in front of us, but he is actually a very caring son in front of his mother. His mother is suffering from cancer and he goes to the hospital to visit her every other day. I don't think I can lie to her for a whole month in his absence. His mother would worry sick once she finds out the truth, maybe even worsens her condition." Tears were about to spill out of Gorilla's eyes as he spoke.

quarrelsome (形) 愛鬥嘴的、爭論的 pain in the neck (習) 令人討厭的人

Watson knew well that although Gorilla and Fox might squabble with each other like children in a playground most of the time, deep inside they were actually very good friends. They never showed their true feelings because their arrogance always got 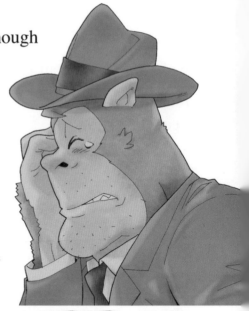 in the way. Now that Fox was in dire straits, Gorilla was so overwrought that he did not know what to do but to ask Holmes for help.

"We must get a clear picture of what's going on as quickly as possible in order to help Fox out of danger." Holmes took a pause before asking in a serious tone, "Exactly how did Fox become a suspicious case of the Black Death? Was he in close proximity to a patient suffering from the Black Death?"

"Not a patient. It was a dead body…" Gorilla recounted in detail how he and Fox came across the

squabble (動) 為小事爭吵　　arrogance (名) 傲氣、威風　　dire straits (名) 危難、生死關頭
overwrought (形) 神經質的、過度緊張的　　in close proximity to (習) 近距離接觸

Black Death victim.

"I see," nodded Holmes after listening to Gorilla's story. "So the coroner confirmed that the victim had died from the Black Death?"

"The coroner heard from those in the know that the Black Death has **allegedly** spread to London already, so he was in an even bigger panic than I. He examined the body hastily then had it cremated straightaway."

"Did he do an **autopsy**?" asked Holmes.

"Why would he go through such trouble? Everyone was so frightened and confused that the best thing to

coroner (名) 驗屍官 allegedly (副) 宣稱、據稱 hastily (副) 草率地、匆忙地
cremate(d) (動) 火化 autopsy (名) 驗屍、解剖

do was to cremate the body straightaway. It's the only means to kill off the bacteria thoroughly and prevent it from spreading," replied Gorilla.

Holmes cringed his eyebrows at once. "Was that really the best thing to do? What if it turned out to be a false alarm and the victim actually didn't die from the Black Death? What if there is no reason to panic at all?" disagreed Holmes with the police's haphazard procedure.

"No, it's definitely the Black Death!"

"How could you be so certain?"

"Because after the first Black Death victim was found, two more dead bodies with darkened skin were discovered in the same slum area. This proves that the Black Death is already spreading in that particular slum. Otherwise, why would there be three victims dying in the same way on the same day in the same

haphazard (形) 草率的、隨意的、無計劃的　　slum (名) 貧民區

area?" said Gorilla.

Watson was greatly taken aback. If what Gorilla was saying were true, then a deadly infectious disaster was about to sweep across London.

"What about the other two dead bodies? Where are they now?" asked Holmes *eagerly* .

"They were cremated straightaway, of course. Where else could they be?" Gorilla seemed baffled at Holmes's question.

"Those two bodies were also cremated without doing autopsies?"

"Yes. Actually, all three bodies were cremated at the same time. The coroner said that the discovery of three dead bodies with the same black skin appearance in the same area almost unquestionably proves that the Black Death rumour is true. Conducting autopsies would only be a waste of time," said Gorilla.

eagerly (副) 急切地　　baffled (形) 困惑的　　rumour (名) 謠傳、流言

Watson nodded in agreement and said to Holmes, "As a doctor, I agree with the measures taken by the coroner. We read in the newspaper that the Black Death is already spreading in Hong Kong and India, possibly even carried to London via commercial ships. As an act of **precaution**, immediate **cremation** is the only way to stop a potential **catastrophe**."

"Immediate cremation may be a suitable solution in the prevention of an outbreak, but from an investigation point of view, cremation is the same as destroying important evidence. We can't say for sure now whether or not the three victims had really all died from the Black Death!" said the slightly angry Holmes. He hated it whenever evidence that could help solve a case was destroyed.

Only after listening to Holmes did Gorilla realise how **problematic** the situation had become, "So what can we do now?"

Holmes sighed, "The only thing we can do now is find the answers to these three questions

precaution (名) 預防措施 cremation (名) 火化 catastrophe (名) 大災難
problematic (形) 困難的

26

and hope that some *clues* would come to light.

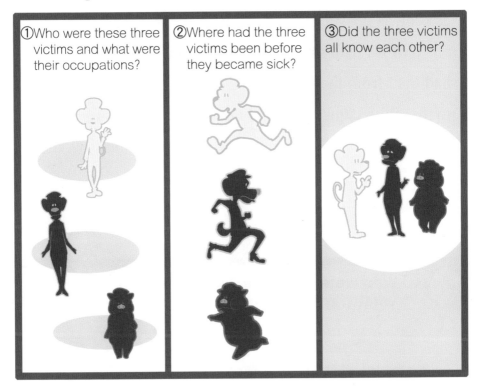

①Who were these three victims and what were their occupations?

②Where had the three victims been before they became sick?

③Did the three victims all know each other?

"Okay, I'll look into it right away!" Gorilla jumped up and ran out of the door after dropping those words. Holmes's **query** seemed to have brought some hope to Gorilla. If those three victims really had not died from the Black Death, then it would not be necessary to isolate Fox, which meant Fox's mother in the hospital would not be disturbed. Gorilla fully understood that

clue(s) (名) 線索　　query (名) 疑問　　disturb(ed) (動) 騷擾

the best way to help his partner was to clarify the truth as soon as possible.

"Will we really know whether or not the three victims had died from the Black Death after finding the answers to those three questions?" asked Watson.

"It's hard to say, but answering those questions would definitely help us better understand the three deaths," said Holmes as he explained the importance of the three questions.

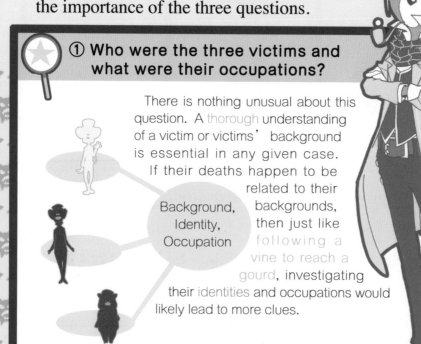

① Who were the three victims and what were their occupations?

There is nothing unusual about this question. A thorough understanding of a victim or victims' background is essential in any given case. If their deaths happen to be related to their backgrounds, then just like following a vine to reach a gourd, investigating their identities and occupations would likely lead to more clues.

Background, Identity, Occupation

definitely (副) 肯定地、毫無疑問地　　thorough (形) 徹底的、透徹的、全面的
following (follow) a vine to reach a gourd (習) 順藤摸瓜　　identities (identity) (名) 身份

② Where had the three victims been before they became sick?

If the culprit really turns out to be the Black Death, then we must identify the source of infection. The three victims died almost at the same time, which means they must've been infected at around the same time too. If all three victims had been to the same place before they became sick, then they were probably infected in similar ways, which is helpful information when looking for the infection source. On the contrary, if there were no connecting points between the victims, then it's likely that the disease has spread already, making the investigation more challenging than it already is.

③ Did the three victims all know each other?

Clarifying this point is very important. If the victims knew each other and had met with each other recently, then it's possible that two of the victims caught the disease from the one already infected. But if this were true, the case would become more complicated since we have no way of knowing now which one of them was first infected, given that the bodies are all cremated, and a lot more time would be needed to identify the infection source.

culprit (名) 罪魁禍首　　connecting point(s) (名) 交接點

"I see." Watson could not help but praise Holmes's intellect, "You are even more insightful than a doctor when it comes to investigating the deaths of an infectious disease."

"Your words are too kind, my dear Watson. Actually, all I'm doing is treating the infectious disease as a murderer. The method that I've told you just now is similar to the method of investigating a serial killer, because there are many common points between the two," said Holmes with a shrewd chuckle.

"There are many common points between the two?" Only then did Watson finally understood Holmes's reasoning as the common points between the Black Death and a serial killer appeared in his mind.

intellect (名) 聰明才智

30

★The Black Death kills many people continuously. A serial killer, as the name suggests, kills people repeatedly.

★The Black Death kills with deadly bacteria through infecting people in similar manners. A serial killer tends to employ the same kind of methods and use the same kind of weapons in his or her series of murders. So a serial killer who stabs with a knife will tend to use knives in all the murders and one who shoots with a gun will keep on using guns.

★Victims of the Black Death are similar in the sense that they have all been to places infected with the bacteria, they have weak immune systems and have difficulty fighting off diseases, they know each other whether directly or indirectly, so forth and so on. The victims of a serial killer are similar because serial killers tend to choose the same type of people as their targets. A serial killer who murders prostitutes will keep on targeting prostitutes. One who murders women will keep on targeting women. One who murders children will keep on targeting children. Or if a serial killer is easily triggered by the colour red, this killer might target people wearing red clothes.

bacteria (名) 細菌　stab(s) (動) 刺　immune (形) 免疫的
trigger(ed) (動) 觸發

As Watson **wrapped up** his thoughts, he was overwhelmed with a sense of joy in realising the whole picture. He turned to Holmes admiringly, "I see what you mean now. It's as though the three victims were killed by a serial killer named 'Black Death'. And to chase after this serial killer, we must first find the answers to those three questions!"

"**Precisely**. It's as simple as that."

"What should we do next then?" asked Watson.

"We wait. It's late at night now. Before Gorilla comes back with the answers, the only thing we can do is wait."

"Too bad I need to go to Paris tomorrow to attend a conference at a university for a few days and can't follow through with this case," **groaned** the annoyed Watson.

"Gorilla and I will **get to the bottom of** this. Don't worry, Watson. Just enjoy your trip." On that note, Holmes let out a lazy yawn as he headed back to his room and went to bed.

wrap(ped) up (片語動) 結束　precisely (副) 對、正是、的確
groan(ed) (動) 抱怨、埋怨　get to the bottom of (習) 查個水落石出

The Fourth Victim

Early next evening, Alice came up to the front door of 221B Baker Street with a telegram in her hand. Holmes cringed his eyebrows as soon as he saw her, "Why are you here again?"

Readers familiar with Alice should know well that although our great detective was renowned for his fearlessness, Alice was probably the one person in this world he feared most. The daughter of the landlady's relative, Alice often came over to stay with the landlady for a few days during her school holidays. And her showing up at Holmes's front door usually meant she was helping the landlady to chase up Holmes for his overdue rent*.

*For details, please refer to *The Great Detective Sherlock Holmes ④ The Mystery of the Vampire*.

telegram (名) 電報　renowned (形) 聞名的、著稱的

Just one look at his face and Alice knew exactly what Holmes was worried about. With a big friendly smile, Alice said, "Don't worry, Mr. Holmes, I'm not here for your overdue rent." She then handed the telegram to Holmes.

"A telegram? For me?"

"Yes. The landlady asked me to bring it to you."

Holmes opened the telegram immediately. A **grim** expression came over him after reading the telegram:

Another victim has been discovered. Please come onto the Wales Freight by Greenland Dock as soon as possible.

Gordon Riller

"Another victim?" Holmes muttered under his breath.

"What is it? What victim?" asked the curious Alice as she stretched her neck to peek at the telegram.

"Mind your own business, **nosy** girl! Off you go! Shoo! **Begone** !" ordered Holmes

grim (形) 沉重的、嚴肅的　mutter(ed) (動) 喃喃自語　stretch(ed) (動) 伸出
nosy (形) 好管閒事的、愛打聽的　begone (感嘆) 走開

sternly, frantically stuffing the telegram into his pocket as he tried to send Alice away.

"Okay. Chill out! Just asking a question," grumbled Alice as she walked off.

After Alice was gone, Holmes put on his coat and left Baker Street right away.

An hour later, Holmes's carriage pulled up to Greenland Dock, the largest port in London. Holmes quickly hopped off and spotted the Wales Freight in no time. Waiting for Holmes beside the cargo ship with a mask on his face was Hippo, the patrol officer whom Gorilla and Fox met yesterday.

chill out (片語動) 冷靜、不用緊張　　grumble(d) (動) 抱怨、發牢騷
hop(ped) off (片語動) 跳下

"Mr. Holmes, please come this way." Holmes followed Hippo into the large ship. After walking through the meandering corridors inside the ship, they finally reached the cabin that was also the crime scene.

Standing outside the cabin's door in "**full gear**" was Gorilla with a mask on his face and white gloves over his hands.

"Is the body still inside the cabin?" asked Holmes.

"It's still inside. The coroner wanted to cremate the body straightaway but I stopped him. However, the coroner is only giving us 30 minutes for inspection before taking the body away for cremation," said Gorilla as he handed a face mask to Holmes.

meandering (形) 迂迴曲折的 full gear (名) 全套武裝

Holmes put on the face mask then went into the cabin. The room was not as stuffy as expected since the round window in the cabin was open. A light, salty-smelling sea breeze was blowing through the window. The evening was closing in and there was not much lighting inside the cabin.

The victim was a short, middle-aged man lying on the single bed. His face looked as though he was still sleeping and there seemed to be no signs of struggle or trauma.

breeze (名) 微風　　trauma (名) 創傷、嚴重外傷

"We've already asked the ship's captain and the sailors to identify the body. The victim turns out to be the owner of this ship. His name is Victor Savage. But none of the men knew why Savage was lying on the bed in this unoccupied room since Savage has his own luxurious suite elsewhere on board," said Gorilla.

Holmes gave a nod to Gorilla then walked towards the dead body cautiously. Holmes took out his magnifying glass to examine the victim's skin more closely then leaned towards the victim's face to look at the cheeks over and over again. Under the magnifying glass, Holmes could see that the victim's left cheek had four light scratches. As Holmes continued to inspect the body, some black spots on the floor caught the corner of Holmes's eye, so he knelt down for a better look.

"What is this doing here?" muttered Holmes.

"What is it? Did you find something?" asked Gorilla eagerly.

scratch(es) (名) 抓痕

"This looks like **charcoal debris**. An examination will be needed to confirm," said Holmes as he took a pinch of the black debris off the floor and wrapped it up with a piece of white paper.

"Charcoal debris?" Gorilla thought for a moment before continuing, "There's nothing odd about that. This ship burns coal so it's not unusual if bits of coal were stuck on the bottom of people's shoes then brought into the cabin."

"Are you confusing **charcoal** with coal? They are two very different things. You can't mix them up," clarified Holmes as he stared at Gorilla **incredulously**.

"Really? Sorry about that." Gorilla scratched his head in embarrassment as he let out an **awkward** chuckle. "Is it possible that the victim stepped on some charcoal then brought the debris into the cabin himself?"

Holmes walked to the end of the bed and inspected the bottom of the victim's shoes,

charcoal debris (名) 木炭碎　　pinch (名) 少量、一撮　　charcoal (名) 木炭
incredulously (副) 難以置信地　　awkward (形) 尷尬的

"I don't see any signs of the victim having stepped on charcoal, otherwise the bottom of his shoes would show some unique black **blotches** left by the charcoal."

A gust of wind suddenly blew through the round window. While the cold gave Holmes a little ¦shiver¦, it also brought Holmes's attention to the window, "Did the police open that window after arriving at the scene?"

"No. According to the sailor who discovered the dead body, that window was already open when he walked into the cabin," replied Gorilla with certainty. "The sailor thought it was strange too. It's been pretty cold lately so the windows shouldn't be open."

After moving his eyes from the dead body to the round window, Holmes cringed his eyebrows and fell into deep thought.

Waiting in silence was simply not in the nature

blotch(es) (名) 污漬、斑點　　shiver (名) 冷顫、顫抖

of our impatient Gorilla, so he urged, "Come on, let's clear out of here. The sooner the body is taken away and cremated, the better the chance we have in containing the disease and preventing it from spreading." Actually, it was not Gorilla's impatience but his fear of the disease that was prompting him to retreat at once from the **eerie** cabin.

"Hold on a second. Have you checked if the victim was carrying anything on him?" Holmes turned to ask Gorilla.

"We've checked already. His belongings are in this bag. The only things we found on him are a wallet, a handkerchief, a pocket watch and a set of keys," said Gorilla as he held up a square paper bag.

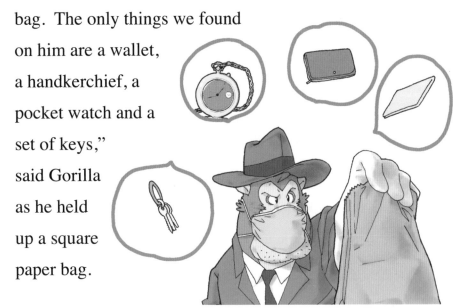

retreat (動) 撤退、離開　eerie (形) 怪異的、可怕的、令人不安的

Holmes took the paper bag and pulled out the items inside. Seeing nothing out of the ordinary about them, Holmes asked, "Was there any cash in the wallet?"

"There were a few banknotes."

Holmes opened the wallet and pulled out the contents for a look. Sure enough, there were a few banknotes inside and nothing else.

"The victim has died from the Black Death. This isn't a robbery gone wrong. It's no use going through his wallet," said Gorilla.

"I know. The money is still in the wallet, which proves that no robbery was involved. I just wanted to see if there are any foreign currencies in the wallet. If so, the victim might have been out of the country recently."

"I think I haven't told you yet," said Gorilla as something suddenly sprang to his mind. "The captain said the victim had just returned from India a little more than a week ago. The disease might've been carried back from India via this ship."

banknote(s) (名) 紙幣、鈔票

Since India was an infected area of the Black Death, Holmes was taken aback after hearing those words.

"Not only that," added Gorilla, "remember the three victims that we found yesterday? Those three men were seen near this ship a few days ago."

"What?" uttered Holmes in surprise. "Does this mean the source of the three men's infection was this ship?"

"Looks like it," said Gorilla.

"Were you able to find anything on the three men's identities and backgrounds?"

"Yes. One was an old man who collected scraps for a living. One was a middle-aged bloke who worked as a coolie*. One was a young *opium addict*. All three men lived alone and had no families to call their own. And they didn't know each other."

"Hmmm…" As Holmes mulled over the information on the three victims, his line of sight returned to the banknotes that were still in his hand. All of a sudden, he stared at the banknotes with his eyes wide open as

* A coolie is an unskilled and cheaply employed labourer who is originally from Asia. 'Coolie' is now considered to be a derogatory term, but the word was commonly used during the period of the story.

scrap(s) (名) 廢物、垃圾　　bloke (名) 傢伙（稱呼男人的俚語）　　coolie (名) 苦力
opium addict (名) 吸食鴉片的癮君子　　mull(ed) over (片語動) 仔細思考、反覆考慮

though something had caught his eye.

"Is something wrong?" asked Gorilla curiously.

"Look here. There are three names on this banknote," said Holmes as he handed one of the banknotes to Gorilla.

"Oh!" Gorilla could see three names written on the banknote. The names were Culverton Smith, Michael Stewart and Richard Bloom. They were all names of Englishmen.

Gorilla thought for a moment then asked, "Some people like to *jot* things *down* on banknotes when they can't find any paper near them. Maybe Savage got this banknote with the three names on it by chance when he was shopping and money was exchanged?"

"Highly unlikely."

"Why is that?"

"Because of these three names."

"What do you mean?"

"They are all experts."

"What sort of experts?"

jot something down (片語動) 匆匆寫下

"They are London's topmost prominent experts on infectious diseases!" said Holmes as a chilling glimmer flashed across his eye.

"Oh!" gasped Gorilla. He knew right away what our great detective was trying to say. The victim, Savage, died from the Black Death and a banknote written with the names of infectious disease experts was found in his wallet. This could not be a coincidence. So exactly what could be the mystery behind those names?

"After you came by my flat yesterday, I reviewed some information on the Black Death and came across the names of these three experts. They've all been researching on the Black Death and they are all professors at The Medical School of Great Britain," said Holmes.

"I see," uttered Gorilla.

"Can you check if the handwriting on the banknote belongs to Savage himself please?" instructed Holmes. "In the meantime, I shall drop by the offices of these three infectious disease experts and find out how they are connected to the victim."

Without any difficulty, Gorilla was able to confirm

topmost (形) 第一的、數一數二的　prominent (形) 著名的、卓越的
mystery (名) 謎、神秘的事物　utter(ed) (動) 說、講　confirm (動) 確定、證實

that the handwriting on the banknote really did belong to the victim after showing the banknote to the victim's family. According to Savage's wife, Savage had a bad habit of jotting important things down on banknotes instead of using a notepad.

Meanwhile, Holmes went to visit the three experts on infectious disease. They all claimed that they did not know

 the victim and they all had no clue why their names were written on the victim's banknote.

However, from his meeting with each one of the experts, Holmes could sense that something **shady** must be lurking behind.

shady (形) 可疑的　　lurk(ing) (動) 隱伏着、潛藏

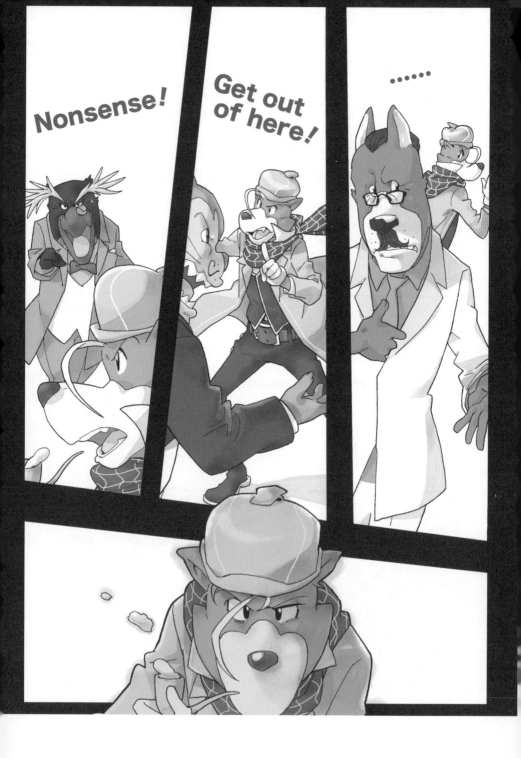

The Dying Detective

Five days later,
Watson was
on a train
back to London.
Before the train
had even come to a halt, he
jumped off the train with his luggage
in his hand then rushed out of the train
station as quickly as he could. Running
through his mind repeatedly was a message that read,
"Mr. Holmes is in *critical condition*. Please come
home immediately!"

Those words were written on a telegram that he
received yesterday and the sender was the landlady.
Watson's medical conference in Paris was supposed to
go on for another day, but he found it impossible to sit

halt (名) 停下來 critical condition (名) 情況危殆、病情危重

still after reading the telegram so he decided to **hop on** the next train back to London instead.

"Dr. Watson, this way!" shouted a voice as soon as Watson stepped out of the train station.

Watson stopped walking right away. He raised his head to search who was calling out to him and saw Alice running towards him.

"Alice, why have you come here?" asked Watson.

"The landlady asked me to come **fetch** you. She couldn't come herself because she needs to look after Mr. Holmes. He is very ill," said Alice as she tried to **catch** her **breath**.

"What happened? I was only gone for a few days. How come Holmes is suddenly in critical condition?" asked Watson **anxiously**.

"I don't know either. It seems like Mr. Holmes started

hop on (片語動) 跳上　fetch (動) 接　catch one's breath (習) 喘口氣
anxiously (副) 焦急地、擔憂地

to feel sick about four days ago. The landlady said he has locked himself in his bedroom and wouldn't let her in."

"What? How could that be? Doesn't he need to eat?" asked Watson incredulously.

"The landlady has been leaving food outside Mr. Holmes's bedroom door, but he hasn't touched a thing. This went on for a few days and she thought it was strange, so she went into his room despite his objection. Only then did she see how pale and sickly he looks. He even told the landlady to stop bringing him food because he has no appetite at all," said

Alice as she **sobbed**.

"Have you asked for a doctor?"

"We wanted to but Mr. Holmes wouldn't let us. It wasn't until yesterday when he told us that you are the only doctor he is willing to see."

Watson was greatly taken aback and could not stop

appetite (名) 胃口、食慾 sob(bed) (動) 啜泣、嗚咽

the words 'Black Death' from flashing in his mind. He already had a bad feeling about the Black Death as soon as he read the telegram in Paris, but after listening to Alice, he was now almost certain that Holmes might be infected with the deadly disease, because Holmes was investigating a case concerning the Black Death right before Watson left London.

Although Watson understood Holmes's **insistence**, he still could not help but stomp his feet in anger, "How could he be so stupid? He should consult another doctor when I'm not around! What if his condition worsens?"

infect(ed) (動) 感染　　insistence (名) 堅持　　stomp (動) 重力地踏、頓腳 (表示生氣的情緒)

"The landlady tried to persuade him too but he wouldn't listen. You know how stubborn Mr. Holmes is. Once he has made up his mind, nobody can convince him otherwise," said Alice helplessly.

"That is true. Anyway, let's hail a cab and go home right away!"

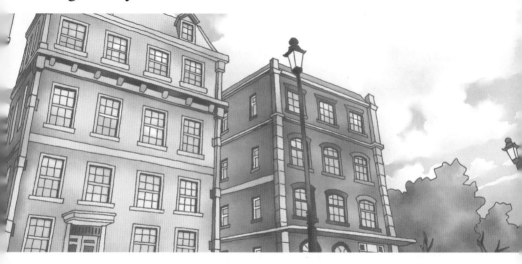

Half an hour later, Watson and Alice had returned to 221B Baker Street.

The landlady was walking down the stairs worriedly as Watson was rushing up the stairs. As soon as she saw Watson, a look of relief came onto her face. She took Watson's hand and said, "Oh, Dr. Watson! I'm so

persuade (動) 勸導、說服　hail (動) 召喚、揮手截停　relief (名) 如釋重負、解脫

glad to see you back! Mr. Holmes has been sick in bed for four days. He refuses to eat or drink anything, not even a sip of water."

"Alice has told me already. Don't worry, you go rest up and let me take over," reassured Watson.

Watson continued to run up the stairs after saying those words, leaving Alice to comfort the landlady.

Once upstairs, Watson darted straight to Holmes's bedroom and barged in without knocking on the door, "Holmes, how are you feeling?"

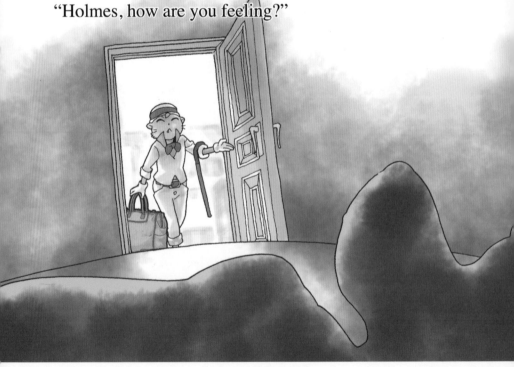

sip (名) 一小口　　reassure(d) (動) 使人安心地說着、安慰

"Oh... Watson... You're back already?" greeted Holmes, lying in bed with a voice as thin as vapour. "I... I think I'm falling down to hell soon."

"Please don't say that!" Watson instinctively stopped his old partner from uttering gibberish that sounded like sleep-talking. However, Watson could not help but feel a chill run down his spine, because lying in bed inside the gloomy room was an extremely haggard and pale Holmes that was almost unrecognisable.

It was just five days! Watson had not seen Holmes for just five days, and now the usual vigour on Holmes's face was completely gone!

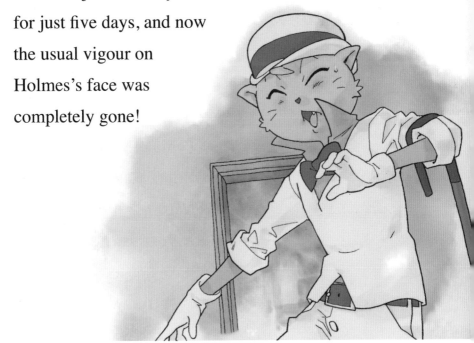

as thin as vapour (形) 薄弱的　　instinctively (副) 本能地、直覺地　　gibberish (名) 胡言亂語
haggard (形) 憔悴的、消瘦的　　unrecognisable (形) 認不到的、無法識別的

Holmes's complexion was a dull grey and his 'lacklustre' eyes were bulging out like a dead fish. Even under the dim lighting in the room, Watson could see that the skin around Holmes's cheekbones was dry and cracking from severe dehydration. Moreover, Holmes's hands kept trembling on top of his duvet, as though the grim reaper was summoning him from a hair's breadth away.

"Holmes!" cried Watson as he lunged towards Holmes.

"No, Watson! Don't come near me!" shouted Holmes suddenly to stop Watson. "I'll make you leave the room if you take one more step!"

"But why?" asked

complexion (名) 面色、膚色　　dull (形) 暗啞的、無光澤的
lacklustre (形) 毫無生氣的、無神的　　bulging (bulge) out (片語動) 凸出
dehydration (名) 脫水　　trembling (形) 顫抖的　　duvet (名) 羽絨被、厚被子
56　　the grim reaper (名) 死神　　a hair's breadth (片語) 極近、極短的距離　　lunge(d) (動) 撲向

Watson as he took a fearful step backwards.

"Just don't come any closer." Although Holmes's voice was sounding very weak, his tone was as firm as ever.

"But I want to help you," pleaded Watson.

"The best way to help me is to do as I say."

"Okay, fine. How may I help you then?"

"Aren't you angry with me?" asked Holmes.

"I can't bear to see you like this. Being angry is not my priority right now," said Watson.

"Very well. You know I'm only doing what's best for you."

"For me? What do you mean?"

"It's the Black Death. I'm infected with the Black Death and I don't want to pass it onto you," uttered Holmes with a voice so frail that it sounded as though an immense effort was needed to squeeze it out from his throat.

priority (名) 首要事項、優先考慮的事　frail (形) 虛弱的
immense (形) 艱巨的、極大的　squeeze out (片語動) 擠出

57

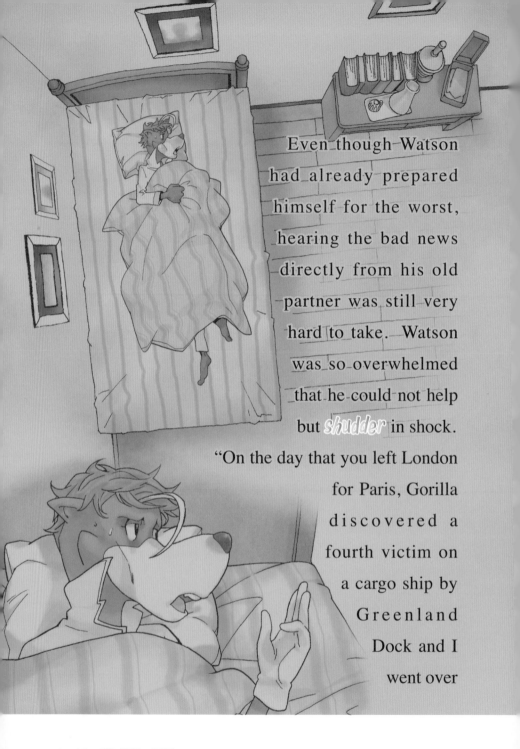

Even though Watson had already prepared himself for the worst, hearing the bad news directly from his old partner was still very hard to take. Watson was so overwhelmed that he could not help but *shudder* in shock.

"On the day that you left London for Paris, Gorilla discovered a fourth victim on a cargo ship by Greenland Dock and I went over

shudder (動) 發抖、顫抖

58

to help with the investigation. I must've contracted the disease at that time," added Holmes.

Wanting to be nearer his friend, Watson took a step forward after hearing those words.

"Don't come closer!" cried Holmes angrily with his bulging eyes wide open.

"Please, Holmes, let me take a closer look at you," begged Watson. "I'm a doctor. I'm not afraid of the Black Death."

"So what if you are a doctor? Are doctors immune to the disease?" mocked Holmes with a feeble chuckle. "Don't try to be brave and foolish, Watson. If you take one step closer, I'll have to make you leave. I'm serious."

mock(ed) (動) 挖苦地說、嘲弄　　feeble (形) 虛弱的、無力的

"Fine. I'll stay where I am." Watson had no choice but to comply. He knew that it would be harder for him to help his sickly partner if he were made to leave the room.

"There is only one thing that you can do if you want to save me."

"What is it? What can I do for you?" asked Watson, his eyes lit up with a glimmer of hope.

"There are three experts on the Black Death in London. Rumour has it that they are conducting clinical experiments in secret. Perhaps they've already found a way to cure the Black Death," said Holmes.

"Really?" Watson simply could not believe his ears.

comply (動) 服從、遵守　clinical experiment(s) (名) 臨床實驗

He himself was a practitioner in the medical field, yet he had not heard of such a rumour.

Ignoring Watson's astonishment, Holmes raised his thinning arm and pointed wobbly at the coat hanging on the wall, "You'll find a banknote in my coat pocket with the names of the three experts written on it. Please go find them at once. Maybe there's hope for me if they're willing to come treat me."

Watson found the banknote right away after a brief search in the coat pockets. Sure enough, three names were written on the banknote. The names all seemed familiar to Watson. Perhaps he had come across those names somewhere before.

"They are all professors at The Medical School of Great Britain," said Holmes.

"No wonder the names looked so familiar. I remember now. They are all renowned scholars. And Culverton Smith is the director of The Medical School of Great Britain," said Watson as he pointed at one of

practitioner (名) 執業者　　wobbly (形) 搖晃的、不穩定的

the names on the banknote. "It's not unusual for you to have heard of these three famous doctors since you're a medical professional yourself." Holmes took a pause as though to gather the remainder of his strength before continuing, "What's strange is that this banknote was found on the body of the fourth victim who died on the cargo ship. Gorilla had already confirmed that the handwriting on the banknote belonged to the victim. I had also paid visits to the three professors and they all claimed that they didn't know the victim. Both Gorilla and I are at a loss. We just don't understand why the victim had written down the names of these three famous doctors."

"We can figure out that mystery later. It's more important now to ask them to come here to treat you first," said Watson.

"You are right. All three professors will be attending an internal meeting this afternoon at the university's main conference room. A short 15-minute recess is scheduled at five o'clock. You must make good use of the time and persuade them within the 15-minute recess. Otherwise, they'll continue with their meeting until eight o'clock in the evening."

"Okay, I understand. If I leave now, I should be able to reach the university before five o'clock," said Watson.

"Oh...." Holmes suddenly let out a distressing *moan* as though he was in great pain.

moan (名) 呻吟

"Holmes, are you feeling okay? Is something wrong?" asked Watson anxiously.

With his eyes closed, Holmes muttered groggily, "Oysters… Oysters can reproduce so quickly… so how come… how come they're not filling up the ocean…?"

"What are you talking about?" asked the bewildered Watson.

"Oysters filling up the ocean… Why isn't the seawater spilling out…?"

"Oh!" Watson wondered if Holmes's gibberish was a sign of disorientation caused by his illness.

To test whether or not Holmes was lucid, Watson asked, "Do you know who is Bunny? What comes to your mind when I mention Bunny?"

"Naughty… annoying… impish…"

That sounded right.

Those were the most suitable words to describe Bunny.

groggily (副) 神智不清地、無力地　　bewildered (形) 困惑的　　disorientation (名) 精神恍惚
lucid (形) 頭腦清晰的　　impish (形) 頑皮的

"What about Alice? What comes to your mind when I mention Alice?" asked Watson further.

"Money… money… vampire… a seductive, blood-sucking she-devil…"

Watson was utterly taken aback. He could not believe that his old partner would associate Alice with a seductive, blood-sucking she-devil! Perhaps Holmes really was losing his mind.

Just to make sure, Watson asked Holmes one more question, "What about Watson? Do you know him? What comes to your mind when I mention Watson?"

"A **quack** … fake **candour**… a lecher…"

seductive (形) 有魅力的　　associate (動) 聯繫起來、聯想起
quack (名) 冒牌醫生、庸醫　　candour (名) 仁義、正直　　lecher (名) 好色之徒

"What? I'm a quack and a lecher? How could you think of me like that?" Watson was so furious that smoke was coming out of his ears.

"Oh… help me… please… help me…" *groaned* Holmes.

"Oh dear God!" Holmes's groaning brought Watson back to the situation before him. Holmes was only speaking nonsense because of his foggy state of mind. Watson reminded himself not to take Holmes's words seriously as there was still an important task at hand.

However, Watson also knew that sometimes the words of one in a semiconscious state could be the truest. The thought of that really saddened Watson. He had immense respect for his old partner, yet Holmes's image of Watson was most **vulgar**. Despite feeling dismayed and *disheartened*, Watson stayed the course and hurried to the university.

groan(ed) (動) 呻吟　　semiconscious (形) 半夢半醒的、半昏狀態的　　vulgar (形) 庸俗的
dismayed (形) 沮喪的、氣餒的　　disheartened (形) 灰心的、泄氣的

The Experts on Black Death

Watson arrived at The Medical School of Great Britain right when the professors' internal meeting had just broken off for recess. Without much difficulty or delay, Watson was able to find Culverton Smith, Michael Stewart and Richard Bloom, the three renowned experts on infectious diseases.

"Good afternoon, professors. My name is Watson and I am a friend of Sherlock Holmes's," said Watson in a low voice after pulling the three doctors to a corner in the hallway. "He paid you visits a few days ago regarding a case that concerns the Black Death. Unfortunately, Holmes has now contracted the disease himself. I was wondering if you would allow me to take you to see him."

The **distinguished** director of the Medical School of Great Britain, Culverton Smith, cast *a sidelong glance* at Watson before uttering in a **sour** tone,

"Are you talking about that private investigator? Why would I waste my time on him?"

"Are you not aware that your friend, this Sherlock Hums or Horns or whatever, was very rude when he came by last time?" growled the chubby Michael Stewart. "He told us he was suspicious of how our names had ended up on a banknote that belonged to a Black Death victim. He claimed that the disease was being used as a weapon to commit murders and that he would be able to find the killer soon. He even tried to **browbeat** us into cooperating with his investigation. He had been nothing but **disrespectful** to us, and now you want us to help him? Are you out of your mind?"

Taken aback by the professor's

distinguished (形) 傑出的、卓越的　　a sidelong glance (形+名) 斜望一眼
sour (形) 冷淡的、尖酸刻薄的、不滿的　　browbeat (動) 威逼、威嚇
disrespectful (形) 不尊重的、無禮的

responses, Watson had no idea that Holmes was suspicious of these three doctors. Watson could not help but wonder, *How come Holmes didn't tell me about this earlier? Why did he make me come here and ask for their help?*

The tall Richard Bloom, who had been quiet all this time, let out a sigh and said, "The Black Death is an **incurable** disease. There is nothing anyone can do for your friend, not even us."

"But you are the topmost experts on this deadly infection. You must have a way to treat it. Holmes has been sick for four days and he is now on the verge of death. Please, I beg of you. If he doesn't receive treatment soon, he might not be able to make it through tonight," implored Watson as he grasped onto the director's shoulder.

The director **yanked** off

incurable (形) 無藥可救的、不能醫治的 on the verge of (習) 即將、接近於、瀕於
yank(ed) off (片語動) 猛力扯掉

Watson's **grip** right away and said in an ice-cold tone, "He shall be missed."

Michael Stewart then gave Watson a further **shove**, causing Watson to lose his balance and fall on the ground. "Leave now! Your friend is sick because he's too nosy. It's his own fault. He deserves it!" roared Stewart as he swung around his **plump** bottom, stomping off after barking those words.

"I'm sorry but we can't help you. We must return to our meeting now," said Richard Bloom after helping Watson back onto his feet. Bloom shook his head **sympathetically** before stepping away to join his colleagues.

Watson was stunned speechless. He could not believe that not one of the experts was willing to help. Holmes must have said something really **offensive** when he visited them a few days back, yet it was not like Holmes at all to speak that way. Could there

be a special reason behind the rude behaviour? What was Holmes trying to achieve?

Watson pondered for a few minutes but still could not come up with any ideas, so he decided to return to Baker Street. Even though curing Holmes was beyond his ability, the least he could do now was sit beside Holmes during his old partner's last hours. It would be awfully heartbreaking if Holmes were to die alone in that gloomy room.

Watson's carriage ride back to Baker Street did not take long. As Watson stepped off the carriage, he caught a **glimpse** of a darting shadow from the corner of his eye. Watson turned his head immediately but the shadow had quickly disappeared behind the street corner.

*Who could that be? The **silhouette** looks*

the least someone could (can) do (習) 至少能做到的 glimpse (名) 看一眼
silhouette (名) 身影、輪廓

familiar, a bit like Gorilla.
Had he come to visit Holmes
just now? thought Watson.

But Watson had no time to
mull over such a trivial matter.
He should be spending every
minute of his time with his dying friend instead. Just
when he was about to open the front door to their flat
upstairs, Alice came out from the flat and nodded at
Watson with a solemn look on her face. She stepped
aside to let Watson in then closed the door and went
downstairs. Watson could understand her woes, but
he had no words to console her, because he knew that
consoling words at this very moment were not only
ineffective but might also bring about even more sadness.

Watson walked into Holmes's room with a heavy
heart. He still had not figured out how to break the bad
news to Holmes about the doctors' refusal to come to
their flat.

"How was your visit to the university? Were you able

trivial (形) 微不足道的、瑣碎的　　solemn (形) 莊嚴的、嚴肅的
woe(s) (名) 痛苦、悲傷　console (動) 安慰

to find the three experts?" asked Holmes, lying in bed with his eyes open.

"Erm… yes," faltered Watson.

"Are they coming over?"

"……" Watson did not know what to say.

"Are they?"

"Well…"

"Have they refused? Don't worry, Watson. At least one of them will come by." Holmes's voice might have sounded weak but his words were staggering enough to confound Watson. Watson could even detect a hint of something in Holmes's tone.

But what exactly is that "something"? Wait a minute! Isn't that the usual firmness in Holmes's tone of voice, the same

falter(ed) (動) 吞吞吐吐地說　staggering (形) 驚人的、令人震驚的
confound (動) 困惑、混淆　detect (動) 察覺

firmness that could bring out the **zeal** *in me? How come he is wide-awake all of a sudden? Is this a* miracle*? Or is it* terminal lucidity *that's commonly seen in patients shorty before they die?* A string of questions popped up in Watson's mind.

"Holmes, what is it? Why do you sound so sure?" inquired Watson.

"Because one of them is Savage's killer! Now that he knows I'm dying, he will want to come here to **retrieve** the evidence of his murder."

zeal (名) 熱心、積極　　miracle (名) 奇蹟　　terminal lucidity (名) 迴光返照
retrieve (動) 取回

"What?" Watson was utterly taken aback. "Killer? Evidence? What are you talking about?"

Just at that moment, the sounds of a carriage coming to a halt could be heard from outside the window. Following those noises was Alice's greeting at the main door downstairs, "Are you here for Mr. Holmes? He is sick in bed."

Watson propped up his ear for a better listen. He could hear Alice speak in a loud and clear voice, "Dr. Watson? He has not returned yet. Mr. Holmes's bedroom is upstairs. The door is not locked. You can go inside and see him yourself."

Watson thought it was too strange, *Alice definitely saw me at the door when I came home. Why did she lie just now about my return?*

coming (come) to a halt (片語) 停下來 prop(ped) up (片語動) 豎起

76

"Watson, hide under the bed, quick! And don't make a noise," urged Holmes. "Whoever that's coming in is about to reveal the truth!"

Watson had no idea what was going on, but he knew that his old partner must have a reason behind his instructions. Watson crawled under the bed at once, holding his breath in wait for the murderer to show.

"Oh…" Holmes began to moan in pain again as footsteps climbing up the stairs were coming nearer.

The front door **creaked** open and in came a man whose hesitant footsteps suggested that he was looking for a specific room in an unfamiliar house. A moment later, the slow footsteps became louder and louder. Perhaps the visitor had located Holmes's bedroom at last.

crawl(ed) (動) 爬行　　creak(ed) (動) 吱吱作響（開門時發出的聲音）

Seemingly cautious, the sounds of the footsteps came to a halt in front of the bedroom door. Perhaps the visitor needed to peek into the room. After a few seconds, probably after confirming that no one else was inside the room, the visitor took one **unwavering** step after another and stopped right beside Holmes's bed.

unwavering (形) 不猶豫的、堅定的

The Visitor

Hiding under the bed, Watson could only see the visitor's shoes but not the face. *Who is this man? Is he the prominent medical school director, Culverton Smith? Or the professor with the mocking words, Michael Stewart? Or the tall professor who showed a slight bit of sympathy earlier, Richard Bloom?* wondered Watson as he held his breath nervously underneath the bed. With his belly on the floor, Watson propped up his ear while lying in wait for the visitor to speak, hoping to identify the visitor from his voice.

However, there was nothing but total silence. The visitor did not make a noise after he had approached the bedside. His shoes had not moved an inch either. *What is he doing? Is he going to pull out a sharp knife and stab the dying Holmes to death? No, that seems unlikely…* thought Watson as he shook the absurd idea out of his head. *Maybe he is hovering over the bed to*

mocking (形) 嘲笑的　　absurd (形) 荒謬的、可笑的

scrutinise Holmes's face on the verge of death?

"Oh…" Holmes's painful moans disturbed the stagnant silence.

"Mr. Holmes. I've come to see you. Can you hear me?" said the visitor with his voice pressed down low.

This voice…? Who does this voice belong to? The speaker had pressed down his voice so much that Watson was having a difficult time identifying the visitor.

"You… who are you? Watson? Where is Watson?" muttered Holmes.

"Your friend hasn't returned yet. He is running around town looking for help. In fact, he just came by the medical school and paid a visit to my two colleagues and me. Too bad my colleagues aren't *eager* to help you. I'm the only one who is willing to see you. I had to come up with an excuse to slip out of the meeting for this home visit," said the visitor.

Watson figured that the visitor had decided to slip out of the meeting instead of waiting until the meeting was over meant that the visitor needed to come here as soon

scrutinise (動) 細看、仔細觀察 stagnant (形) 死寂的 eager (形) 熱切的

as possible. Perhaps the visitor was worried that his two colleagues might change their minds about treating Holmes after the meeting had ended, which would then be impossible for the visitor to speak with Holmes alone. Holmes must have known this all along. In order to draw the snake out from its **burrow**, this one-on-one meeting with the visitor was a deliberate arrangement. But what could be the intention behind?

"Thank you... I didn't think you would be willing to come save me..." As Holmes's voice broke off Watson's train of thought, Watson realised that Holmes must have identified the visitor already. So who could this visitor be? Watson was feeling so restless that large beads of sweat began to form on his forehead. He wished he could just slide out from under the bed and see for himself!

"I've forgiven you and decided to come here to see you. I'm returning your rudeness with kindness," said the visitor.

Eh? This sarcastic tone... Could he be Michael

burrow (名) 洞穴　deliberate (形) 故意的、有計劃的　bead(s) (名) (汗)珠
sarcastic (形) 諷刺的、挖苦的

Stewart? That plump professor has a habit of speaking in this manner, thought Watson.

All of a sudden, an eerie creak sounded from above Watson's head. Perhaps Holmes had just shifted his fragile body on the bed.

"It's very magnanimous of you… You have a kind heart," said Holmes with a voice as thin as vapour. "I know that…only a distinguished expert like you could help me."

"You are right. The Black Death has been the main subject of my research for many years. My accomplishments have even exceeded my two esteemed colleagues. I dare say that I'm the only man in England who truly understands the Black Death," said the visitor, gradually elevating the volume of his voice as he became more excited from merely talking about his own scholastic achievements.

Holmes coughed a few times then asked, "I'm sorry…

fragile (形) 嬌弱的、脆弱的　magnanimous (形) 寬宏大量的　accomplishment(s) (名) 成就
esteemed (形) 受尊敬的　scholastic (形) 學術的

82

Would you mind pouring me…a glass of water please?"

"Certainly. Your voice sounds coarse. A bit of water should make it better. Otherwise, you wouldn't be able to answer my questions."

From under the bed, Watson could see the visitor's shoes move away from the bedside before hearing sounds of water being poured into a glass. After a short moment, the visitor's shoes returned to Watson's field of vision again.

A few seconds later, Watson could hear Holmes's gulping sounds from above his head.

"Be careful. You're spilling water on yourself," said the visitor. "Do you know where you have contracted the disease?"

"Victor Savage… I must've contracted it from Victor Savage. He was the only Black Death victim that I had encountered."

coarse (形) 沙啞的

"Are you sure? Was there anyone else besides Savage?" The visitor sounded as though he was trying to remind Holmes. "Think back for a minute. Have you come across anything unusual these past couple of days? Maybe there is something else that you could've caught the disease from? I must pinpoint the infection source in order to solve the problem."

"Oh… The pain… I feel awful… Can you please help me ease the pain?"

"Yes, but you must first think back and tell me if anything out of the ordinary had happened before you became ill." The visitor brushed aside Holmes's request and kept on questioning.

"Nothing…" uttered Holmes. "Should there be something? I can't think of anything or anyone else besides Savage."

"You must try to remember. I can't help you otherwise." A hint of *intimidation* could be heard in

pinpoint (動) 確定、準確找到　　brush(ed) aside (片語動) 冷落、漠視
intimidation (名) 脅迫、恐嚇

the visitor's voice.

"I...really can't recall anything."

"Let me try to help you out." The visitor pressed on, "For example, have you received any packages recently?"

"Packages?"

"Maybe a box of some sort."

"Oh... I can't see anything! I'm dying!"

"Holmes! Listen to me! Was a box sent to you or not?" asked the visitor, enunciating every word clearly and sternly.

"A box? Like a birthday gift? But the oysters hadn't sent me a birthday gift." Holmes was talking

enunciating (enunciate) (動) 咬字、吐字　　sternly (副) 嚴厲地、苛刻地

nonsense again.

"Come on! Wake up! It's a box made out of *ivory*. You should've received it four days ago. Did you open the box?" asked the visitor impatiently.

"Oh… I remember now. Yes, a very *exquisite* ivory

box was sent to me, but there was nothing inside. It was empty. It must've been that impish Bunny playing a joke on me."

"But you must've discovered something after opening the box."

"What…?"

"Like a *contraption*, perhaps?"

"Contraption? Ah yes… There was a contraption. I opened the box and springs popped up."

"Yes! Springs! Then what happened next?"

"I think… something *pricked* me. My finger bled.

ivory (名) 象牙　　exquisite (形) 精緻的　　contraption (名) 機關、活動裝置
prick(ed) (動) 刺

It must've been Bunny. He probably wanted to scare me and played a practical joke on me."

"Ahahahaha…" The visitor laughed for the first time. Sounding as though it was coming from deep within his throat, the scornful laughter was so dark that it sent chills down Watson's spine.

"Your memory is back at last. That was not a practical joke to scare you. It was, instead, your infection source!"

"What…? Why…? How did you know that I've received an ivory box? Were you…the sender?"

"That's right. If you weren't so nosy, there would be no need to do this to you. I can tell you now since you're about to die anyway. Savage did not die from the Black Death so he couldn't have passed it onto you.

scornful (形) 輕蔑的

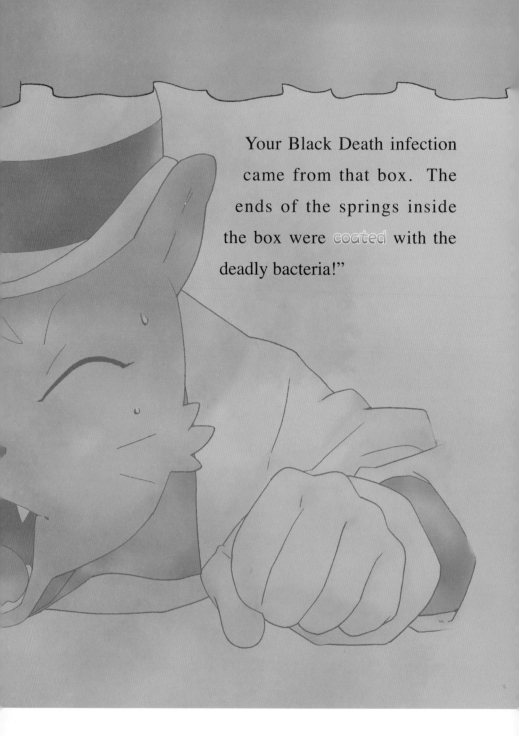

Your Black Death infection came from that box. The ends of the springs inside the box were coated with the deadly bacteria!"

coat(ed) (動) 塗上

Watson wanted to scream after hearing those shocking words. He could not believe that a man could be so evil and use deadly bacteria to kill people.

"The box... It was the box all along..." muttered Holmes in a stammer.

"That's right. Now tell me, where have you put the box?"

Watson finally understood why the visitor had to come see Holmes. His main purpose was to retrieve the ivory box! Watson could not help but wonder, *It sounds like Holmes is* tricking *the visitor into a* confession. *Holmes has just led the visitor to admit to sending the ivory box. Could Holmes's sickness be part of the trick too?*

"Help me..." Holmes's groans of agony broke off Watson's train of thought again. "Please...help me... I will hand you the box if you would agree to save me. I promise I will wipe the incident out of my memory.

trick(ing) (動) 騙、引導　　confession (名) 不打自招、招認　　agony (名) 痛苦

89

HELP !

Please believe me. Save me and I will keep it a secret forever. You have…my word…"

"Ahahahaha…" The visitor's chilling laughter resonated in the room once again. Watson could see the visitor's shoes lightly shaking to the rhythm of the guffaw.

"I know for a fact that you would keep this a secret, not because you are a man of your word, but because you are about to die. Dead men don't talk."

"Please… I beg of you… You are the Black Death expert… I know you can save me if you put your mind to it… Please save me… I will give you the box… I promise…"

"You are such a fool!" shouted the visitor all of a sudden. "It's because I'm the Black Death expert that I can say with certainty that the Black Death is

resonate(d) (動) 回響　　guffaw (名) 大笑

90

incurable. I've spent the past few years trying to develop a drug that would cure the disease, but **clinical trials** on human subjects a few days ago proved that the experimental drug was ineffective. So there is no hope for you. No one can save you and you are going to die! Now hand me the box!"

Clinical trials on human subjects? What did he mean by that? Did he conduct experiments on live men? And where did he find these men? Who in this world would risk their lives willingly and let this mad doctor conduct tests on them like laboratory rats? Watson felt **astounded** and incredulous at the same time.

"So those three victims found in the slum area... They were your human subjects?" asked Holmes.

The visitor let out an icy chuckle, "You seem to have finally pieced the puzzle together. Yes, those three **deadbeats** were my human subjects. It's so easy to find human (guinea pigs) in the slum area. I offered

clinical trial(s) (名) 臨床實驗 astounded (形) 震驚的 deadbeat(s) (名) 無業遊民
guinea pig(s) (名) 試驗品、實驗對象

them three pounds and they agreed straightaway to be subjects in my experiment."

"Those three men were so stupid to throw their lives away like that."

"They weren't that stupid, actually. I was just more clever," boasted the visitor shamelessly. "I told them I needed blood samples for a medical experiment. Instead of just drawing blood, I injected some bacteria that Savage had collected from India into their bodies. Then I gave them injections of the experimental drug to test the formula's effectiveness. Unfortunately, the results turned out to be negative and all three subjects had to be scrapped. I've racked my brain in this drug development for years with no success to show for. Do you have any idea how frustrating that feels?"

What a psychopath! Those were live men, not science experiment subjects! Those men lost their lives but he just treated them as scrap! Where is his

scrap(ped) (動) 毀掉　　rack(ed) someone's brain (習) 絞盡腦汁
psychopath (名) 精神變態者

conscience*? And he still has the* audacity *to call himself a medical scholar?* As a surge of outrage rose within Watson, Watson was finally able to recognise the voice. It was neither director Culverton Smith nor the chubby Michael Stewart. The voice belonged to Richard Bloom, the tall and polite Richard Bloom!

conscience (名) 良知　　audacity (名) 膽量　　surge (名) 一股

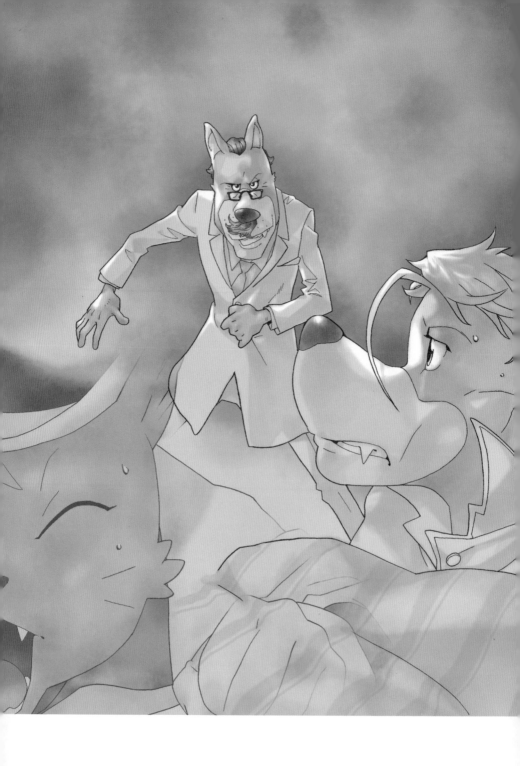

The Reveal

"The subjects were rendered useless and had to be scrapped. The experimental drug proved to be ineffective. As you can see, I don't have any miracle drug to cure the Black Death," said Bloom coldly.

"There's no miracle drug? Oh... I'm going to die... I'm really going to die... That box... You must've killed Savage the same way, to stop him from talking," uttered Holmes in a daze.

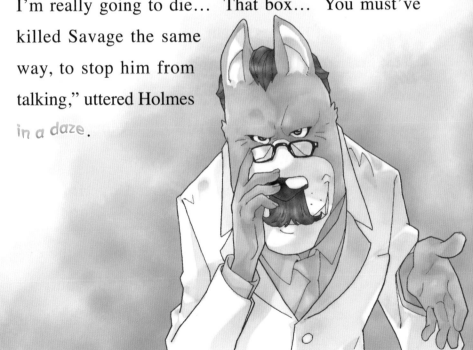

render(ed) (動) 使成為、使變得　　in a daze (片語) 神情恍惚、發懵

"Ha! You really don't **live up to** your reputation as the great detective! Were you not able to figure out Savage's cause of death? He didn't have to die, you know, if he weren't such a money-grubber. I had already paid him for the bacteria at our agreed price but then he came back and blackmailed me for more. He was such a greedy savage, just like his name!" growled Bloom.

"Oh… I feel awful… Help me…" Holmes moaned in agony.

Fearing that Holmes might kick the bucket anytime, Bloom began to panic, "Just give me the box and I will give you some painkillers so you can die comfortably."

"Ha… Haha… Ahahahahaha...!" A loud laughter rolled out from Holmes all of a sudden.

Bloom was stunned and confused by Holmes's amusement.

Holmes sat up in his bed, stared Bloom in the eye and said, "You can save the painkillers for yourself. You will need them while you wait in prison for your

live up to (片語) 不辜負　money-grubber (名) 貪婪的人　savage (名) 野蠻人、粗人
kick the bucket (習) 一命嗚呼、死掉　panic (動) 驚慌

death sentence."

"What?" uttered the astounded Bloom.

"I already knew that Savage had died from carbon monoxide poisoning!" In the blink of an eye, Holmes leapt out of bed and stood right in front of Bloom.

carbon monoxide (名) 一氧化碳

An icy glimmer flashed across Holmes's eye as he pointed at Bloom and shouted, "You are the killer!"

"You've tricked me!" exclaimed the frightened Bloom as his cunning eyes

shifted back and forth in panic. All of a sudden, as though he had figured it all out, he regained his composure and said, "I was only joking with you just now. Nothing that I had said was true."

"A joke? Is that the best *rebuttal* you could come up with?"

"It's my word against yours and you don't have any evidence to back up your accusation."

"What about this box? Isn't your

cunning (形) 狡猾的 rebuttal (名) 抗辯、反駁 accusation (名) 指控

whole purpose of coming here to retrieve this box? This box is evidence of your attempt to kill me," said Holmes as he pulled out from his pyjamas an ivory box and raised it up high.

"You **wretched** hound!" shouted Bloom as he lunged **furiously** towards Holmes like a mad man, his **bloodshot** eyes bulging out.

"Argh!" screamed Holmes as he fell down on the floor from Bloom's tackle. Holmes was usually very

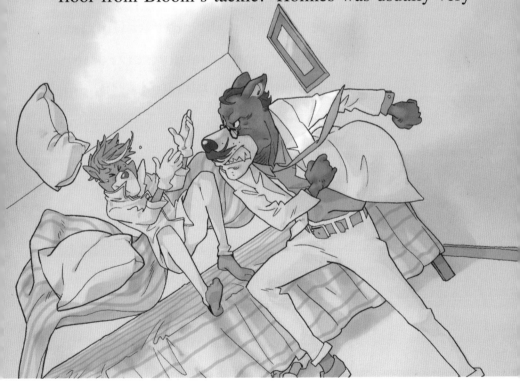

wretched (形) 該死的、討厭的　　furiously (副) 用盡全力地、拚命地、狠狠地
bloodshot (形) 充血的

<u>agile</u> but he could not *dodge* quickly enough this time. The ivory box slipped out of Holmes's hand and landed on the floor right before Watson's eyes.

Bloom immediately dived towards the box, stretching out his hand to reach for it. As Bloom landed on the floor, Watson swung his leg from under the bed and kicked Bloom right smack in the face.

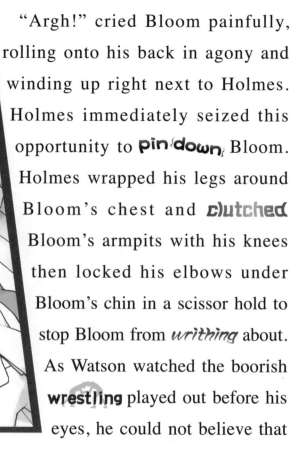

"Argh!" cried Bloom painfully, rolling onto his back in agony and winding up right next to Holmes. Holmes immediately seized this opportunity to **pin down** Bloom. Holmes wrapped his legs around Bloom's chest and **clutched** Bloom's armpits with his knees then locked his elbows under Bloom's chin in a scissor hold to stop Bloom from *writhing* about. As Watson watched the boorish **wrestling** played out before his eyes, he could not believe that

agile (形) 敏捷的、靈活的 dodge (動) 閃身避開 pin down (片語動) 制服
clutch(ed) (動) 緊握 writhing (writhe) (動) 扭動 wrestling (名) 摔角

our great detective had to resort to such a **vulgar** move in order to restrain the tall and unhinged Bloom.

"Don't just stare at me! Go get Gorilla now! I can't hold him much longer!" shouted Holmes.

The shouts brought Watson back to his senses straightaway. Watson quickly crawled out from under the bed and screamed from the top of his lungs, "Gorilla! We need you! Come now!" It was only at that moment that Watson recalled seeing Gorilla's shadow darting behind a street corner nearby. Without a doubt, Holmes had asked Gorilla to lie in wait for his cue.

Before the sound of Watson's **holler** had even died down, the bedroom door swung open with a loud bang and in came Gorilla. Without uttering a word, Gorilla gave Bloom's lower belly a **fierce** kick. The pain from the kick was so sharp and

vulgar (形) 粗野的、不雅的　　holler (名) 大聲叫喊　　fierce (形) 狠狠的

101

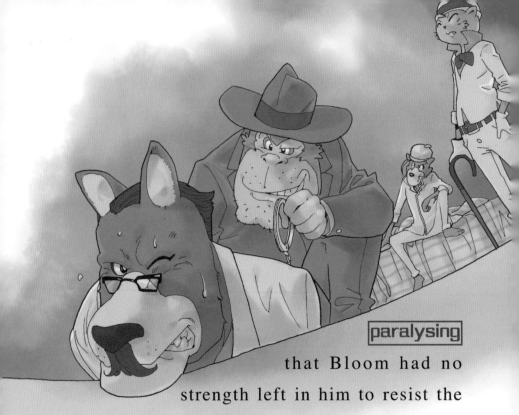

paralysing

that Bloom had no strength left in him to resist the handcuffs and the arrest.

"Is he the murderer? I saw him come upstairs so I followed him and came up too," said Gorilla.

Holmes walked unsteadily back towards the bed and said, "Not eating for four days must've really taken a toll on me. I can't believe I got knocked down by this beast. Yes, this heinous beast is the killer. He has confessed that he's the one who sent me the ivory box. He wasn't aware that I'm always very cautious whenever I receive strange packages. I figured there must be a contraption

paralysing (形) 不能動彈的 take(n) a toll (片語) 造成傷害
heinous (形) 十惡不赦的、邪惡的、令人髮指的

102

inside the box even before I had opened it."

"The victims discovered in the slum area were also his **evildoing**. He injected Black Death bacteria into their bodies. He is a coldblooded murderer!" added Watson.

"No, those were not murders! Those were medical experiments! Don't you understand? If the results had been successful, the Black Death wouldn't be an incurable disease anymore and hundreds of thousands of patients wouldn't have to die from it!" argued Bloom **desperately** with his irrational logic.

Watson's face was flushed red with anger as he listened to Bloom's shameless reasoning. He could not help but shout at Bloom furiously, "You are unbelievable! Using live human subjects to conduct dangerous experiments is the same as intentional killing. You're a doctor and you took an **oath** to 'first do no harm'! How could you **trample** on the lives of

evildoing (名) 惡行　　desperately (副) 拚命地　　oath (名) 誓言
trample (動) 踐踏、無視

innocent people like that?"

"Trample on their lives? They were slum paupers whose lives made no contributions to society! I made sure that I picked subjects with no friends and

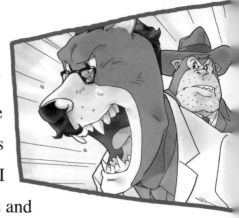

family so no one would shed a tear upon their deaths. They were the best choices as human subjects. By choosing them to participate in the experiment, I was actually giving them a chance to do a good deed that may end up benefitting the world, allowing them to sacrifice themselves for the betterment of the future. It was a cause worth dying for!" The delusional Bloom sounded almost righteous in his impassioned speech.

Whack! A sharp slap landed across Bloom's face.

Gorilla glared at Bloom with round, angry eyes and roared, "Shut up! Stop stinking up the room with your vile rubbish! Save your hogwash for the judge instead!" On that note, Gorilla dragged the monstrous Bloom back to the police station.

pauper(s) (名) 乞丐、貧民 delusional (形) 妄想的、瘋狂的、神智不清的
righteous (形) 正義的 stink(ing) up (片語動) 弄臭、染污 vile (形) 卑鄙的、可恥的
104 hogwash (名) 廢話、一派胡言 monstrous (形) 兇殘的、可怕的、醜惡的

The Cold-Blooded Monster

"Gorilla's slap was brilliant," said Watson after Gorilla had taken Bloom away.

"It was brilliant indeed," agreed Holmes in a frail voice as he _dragged_ his weak body to sit down on the bed.

"Wasn't your illness just an act? Are you really sick?" asked the worried Watson.

"I haven't consumed any food for four days, not even a glass of water. I'm not pretending, Watson. I really am sick, not from the Black Death but from starvation and dehydration," replied Holmes in a rasp.

drag(ged) (動) 拖着　　starvation (名) 飢餓　　rasp (名) 乾澀沙啞聲、喘氣聲

Watson turned from feeling concerned to appearing irritated, "You should've told me earlier. You had me worried sick."

"I couldn't have told you. Don't you understand? I didn't eat nor drink because I needed to fool you, the landlady, Alice and, most of all, Bloom," explained Holmes. "You are an honest man. If I were to tell you the truth, you wouldn't have been able to put on a convincing act to persuade that monstrous killer to come here."

Watson thought over Holmes's explanation for a moment but found it somewhat contradictory, "Hang on a minute. Did you just say that Alice was fooled too? That can't be true. She saw me come upstairs but

she lied to Bloom and told him I hadn't returned yet. Her lie must've been part of your master plan."

"I guess you saw through it," said Holmes with a chuckle. "Yes, her lie was part of my plan. I told Alice the truth about my condition and asked her to put on her greatest performance after you headed out to the medical school. That girl is so clever and **spunky** that I knew she wouldn't **botch** the job."

"I can't believe this! How could you think so little of me? Are you saying that I would **fumble** and Alice wouldn't?" huffed Watson.

"Don't you think so too?" said Holmes **rhetorically**.

Watson felt offended but he knew there was no point to keep arguing with Holmes, so he asked instead,

spunky (形) 膽色過人的　　botch (動) 搞砸　　fumble (動) 失手
rhetorically (副) 反問地

"How did you know that Bloom was the killer?" This question was spinning in Watson's head while he was hiding below the bed.

"I didn't know that he was the killer."

"Really?"

Culverton Smith
Michael Stewart
Richard Bloom

"Really," nodded Holmes. "When I saw the three names written on Savage's banknote, I just suspected that the killer must be one of them."

"How come?"

"There were remnants of charcoal debris at the crime scene. Savage's skin was also flushed red, which was a typical sign of carbon monoxide poisoning."

"I see." As a doctor, Watson was well versed in the signs of carbon monoxide poisoning.

"Moreover, I found four light scratches on Savage's left cheek. From the shape and position of the scratches, I speculated that the scratches must've been caused by the killer's fingernails when the killer smothered

remnant(s) (名) 殘留物　　well versed (形) 熟悉的、了解的　　speculate(d) (動) 猜測、估計

Savage's face with a chloroform-soaked handkerchief."

"I see."

"After Savage had **passed out**, the killer must've moved Savage onto the bed then lit up some charcoal, causing Savage to breathe in large amounts of carbon monoxide in that small, enclosed room. However, the killer had carelessly left some remnants of burnt charcoal on the floor when he came back to remove the charcoal from the room. Also, the window in the room should've been closed since the weather was so cold, yet it was left open. The killer must've opened the window to air out the carbon monoxide as a way to clear out any murder evidence."

"How could that coroner be so stupid and mix up the cause of death from carbon monoxide poisoning to the Black Death?" said Watson as he shook his

chloroform-soaked (形) 浸滿哥羅芳的　　pass(ed) out (片語動) 昏倒、失去知覺

head disapprovingly.

"**Preconception**," said Holmes. "The coroner knew about the three Black Death victims being spotted near the ship before they died. Also, the crime scene was not well lit so the reddened skin on Savage had a similar appearance to the blackened skin on a Black Death victim. That was probably how the coroner came to the wrong conclusion."

"That makes sense," said Watson. "By the way, what did you say to Bloom and the other two doctors when you went to look for them at the medical school? You must've said something really *provoking*, enough to make Bloom want to kill you by sending you the ivory box."

"All I did was telling them firmly that I knew Savage's death was connected to them. I also used some pretty harsh language to insult them and implied that my silence could be bought off. Anyone who

disapprovingly (副) 不滿地 preconception (名) 先入為主、成見
provoking (形) 刺激性的、挑釁的 firmly (副) 肯定地 harsh (形) 苛刻的
bought off (片語動) 收買、買通

wasn't the killer would only hate me for being rude and nonsensical, but the killer would definitely want to shut me up."

"Then you received that deadly box?" asked Watson.

"Yes. I gave the box to Gorilla and asked him to run some tests on it. Results showed that the Black Death bacteria were found all over the ends of the springs inside the box." A cunning smile appeared on Holmes's face before he continued, "So I decided to outsmart the killer at his own game. I pretended to be gravely ill then used your worriment to lure the killer here. I only realised the killer was Bloom when he walked into the room."

"Very ingenious of you," said Watson with a bitter smile. "But what brought the three victims from the slum area to the cargo ship?"

"This kind of human experiments can't possibly be approved by the medical school. Conducting the drug trials at his own home would be too risky and he could get caught easily. It's likely that Bloom had opted for

nonsensical (形) 荒謬的、無理取鬧的　　outsmart (動) 智勝
worriment (名) 憂慮、擔心　　ingenious (形) 聰明的、巧妙的　　opt(ed) (動) 選擇

Savage's cargo ship because even if his experiment were to fail, the police would only suspect that the victims had contracted the disease from the ship and the real truth could stay sealed," analysed Holmes.

"But you figured it all out anyway."

Holmes let out a shrewd chuckle and said, "If Savage hadn't blackmailed Bloom, Bloom wouldn't have killed Savage and the police wouldn't have found out the three victims were spotted near the ship not long before their deaths. Moreover, the banknote written with the three professors' names would've never been discovered on Savage's body, making it impossible for me to pinpoint the professors as *viable* suspects and smoke out the real killer."

"That makes sense. But I still don't understand why Savage had written those three names on the banknote."

"The only man who knows the real answer to that question is Savage." Holmes took a pause before continuing, "But I think my *deduction* shouldn't be too

viable (形) 可能的　　deduction (名) 推理、推論

far off from the truth."

"What's your deduction?"

"I found a medical publication in Savage's house with an article on the Black Death that contained interviews with the three professors. The names of the professors were underlined on the page. Savage probably saw those three names then jot them down on a banknote."

"What for?"

"They were his potential buyers."

"Buyers?"

"In the article, the three professors all moaned about how not having the actual Black Death bacteria to conduct experiments had greatly hindered the progress of their research. The bacterial cultures that were stored in the medical school's laboratory were all destroyed a year ago under the order of the government."

Watson finally got the whole picture, "I understand now. That's why Savage collected the bacteria while he

hinder(ed) (動) 妨礙　　bacterial culture(s) (名) 細菌培養

was in India. He wanted to sell them to the professors."

"Precisely," said Holmes. "It's likely that Bloom was the first man Savage had contacted. Perhaps Bloom was willing to pay such a handsome price for the bacteria that Savage probably had not bothered to contact Smith or Stewart. Then when the greedy Savage found out how Bloom's experiment had caused three deaths, Savage immediately used the information to blackmail Bloom. But Bloom was no **pushover** so he just decided to *get rid of* Savage once and for all."

"Here's something else that I still don't understand. Why didn't Bloom kill Savage with the bacteria but **resorted to** carbon monoxide poisoning instead? Wouldn't that risk *raising eyebrows*?" asked Watson.

"The reason is simple. It takes a few days for an infected victim to succumb to the Black Death after contracting the disease. Savage wouldn't just sit around quietly and wait for his death to come if he knew he was infected with the bacteria."

pushover (名) 善男信女、容易對付的人　　get rid of (片語) 除掉
resort(ed) to (片語動) 採取、採用　　raising (raise) eyebrows (片語) 引人注目、引起懷疑
succumb to (片語動) 死於

"That's true. Savage would probably go to the police or even seek revenge on Bloom."

"Exactly, which was why Bloom opted for a quicker way to kill Savage. Carbon monoxide poisoning is colourless, odourless and doesn't leave any wounds on the body. Bloom probably asked Savage to come collect the money in a room on the ship then used this opportunity to kill Savage and make the death look like another Black Death victim who had just returned from India."

"It really was a perfect murder. Come to think of it, it's ironic that saving lives was Bloom's ultimate goal but he ended up killing four lives before he could even save one. Was it worth it?"

"Watson, you think this way because you're a kind man," said Holmes as his face took on a solemn expression. "From Bloom's cold-blooded actions, I can say for sure that his goal was not to save lives but to serve his own self-interest."

odourless (形) 無味的　　perfect (形) 完美的　　self-interest (名) 個人利益、私利

"His own self-interest?"

"Can't you see? If his experimental drug had been successful, not only would he gain worldwide fame overnight, he could also sell his drug formula at an **obscenely steep price**. Those buyers could be anyone from profiteering **pharmaceutical** companies to dangerously ambitious **rogues** like Dr. M. The formula could be used to produce a cure-all drug, but it could also be exploited to create chemical weapons."

Watson let out a sigh and said, "At first I thought the Black Death was the serial killer. Who would've thought that it was only a weapon used by the real serial killer?"

"Most serial killers are **irrational** and have no self-control, but Bloom had a clear mind and knew exactly

obscenely (副) 離譜地　　steep price (形+名) 過高的價格、不合理的價格
pharmaceutical (形) 製藥的　　rogue(s) (名) 離群及行動異常的人
irrational (形) 不講理的、失去理性的

what he was doing. He was a highly educated scholar, which made him all the more vicious and heinous compared to the average *deranged* serial killer. He truly is a monster, a monster with absolutely no regard for human life!"

"Good thing we're able to bring this monster to justice and stop him from doing more harm to the world." Watson took a pause then suddenly remembered something that he had been dying to ask, "By the way, do you remember what you had said about me when you were in your delusional state?"

"Why yes! I said you were a quack and a lecher."

"How could you say such horrible things? I thought we are friends!"

"Watson, you're so small-minded. Are you still upset over something so petty?" teased Holmes with a mocking chuckle. "I only said those words to make you think that I was critically ill. Did you think I was serious?"

vicious (形) 兇殘的、邪惡的　　deranged (形) 精神錯亂的
small-minded (形) 小氣的、小心眼的、心胸狹窄的

"Oh, thank God!" Watson had never felt more relieved.

"However," said Holmes with a cunning smile, "there was a bit of truth in my words."

"What?" As Watson's face flushed red with anger, Holmes could not help but laugh until tears squeeze out from the corner of his eye.

The murders were successfully solved and the killer was arrested, but what about Fox? What happened to Fox at the end?

Fox was released from the hospital after a month. He never showed any symptoms so all the fuss was nothing but a big scare. He was actually more worried sick than physically sick since he was not allowed to visit his mother at her hospital for an entire month.

As soon as Fox stepped out of the isolation ward, he immediately headed out to see his mother. Surprisingly, Fox's mother looked brighter and happier than the last time he saw her. She even said to him, "I had visitors everyday. I was not lonely at all."

"Really? Who came to see you?" Fox could not believe his ears.

"Someone named Sherlock, someone named Watson and someone else whose name I can't remember. Oh, I'm too old. I can't remember all their names. Oh yes! This chap was always munching on a banana. He was really funny and made me laugh all the time. What is his name…?" Bending her neck sideways, Fox's mother tried her best to recall the name but nothing came to her mind.

After listening to his mother, Fox turned around so his mother could not see his face as he gritted his teeth and

isolation ward (名) 隔離病房　　chap (名／口語) 男人、傢伙
munch(ing) (動) 不停地吃　　grit(ted) one's teeth (習) 咬牙切齒

mumbled in anger to himself, "Those three weasels! How dare they stick their noses in my business! How dare they do a better job looking after my mother than me!"

Fox's mother leaned over to Fox and asked, "Son, why are you crying? I'm fine. Your friends were very kind to me. There's no need to cry."

Only after hearing his mother's words did Fox realise warm tears had spilled out from his eyes. His

mumble(d) (動) 咕噥、喃喃地說　　weasel(s) (名) 衰人、鼠輩

tears suggested to him that he was feeling *moved* instead of angry. He had not expected Holmes,

Watson and especially Gorilla, his ***hot-headed*** work partner, to come and visit his mother everyday and bring joy to his mother when he was not able to do so himself. He felt so blessed to have such good friends.

However, Fox was not used to warm, fuzzy feelings. Even though deep down he felt very grateful, Fox kept mumbling through his quivering lips as he sobbed and *snivelled*, "Boohoo… You three weasels! You three nosy weasels! I won't let you get away with this!"

moved (形) 感動的 hot-headed (形) 急躁的、鹵莽的 snivel(led) (動) 哭哭啼啼

Cool Scientific Facts

【Carbon Monoxide Poisoning】

Written as CO as its chemical formula, carbon monoxide is a colourless, odourless and tasteless gas. It is lighter than air but highly toxic. When a person breathes in carbon monoxide, the toxic gas mixes with the haemoglobin (Hb) in his or her bloodstream and forms carboxyhemoglobin (COHb). As COHb accumulates in the breather's blood, his or her blood begins to lose its ability to carry oxygen, bringing the body to a state of hypoxia.

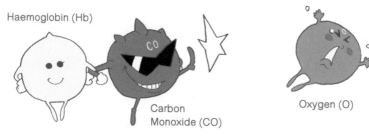

Haemoglobin (Hb)

Carbon Monoxide (CO)

Oxygen (O)

When a person's COHb level reaches 10 percent of total Hb, symptoms like headache and nausea will start to show. At 20 percent concentration, mood instability and impaired judgement will become apparent. Unconsciousness occurs at 50 percent concentration, and death is inevitable at 70 percent or beyond. Because COHb is pink in colour, a classic sign of carbon monoxide poisoning is the visible ruddy appearance on the skin of a victim.

Accidental carbon monoxide poisoning often takes place in homes where fireplaces, stoves or hot water heaters are in use while all the windows are closed. Oxygen is needed whenever fuel is being burnt. When oxygen supply is insufficient, an incomplete combustion happens and carbon monoxide is produced in return. To avoid breathing in carbon monoxide by accident, remember to open the windows and keep the house well ventilated when using fuel-burning household appliances indoors.

haemoglobin (名) 血紅蛋白、血紅素、血色素　　carboxyhemoglobin (名) 碳氧血紅蛋白
hypoxia (名) 缺氧　　nausea (名) 噁心、作嘔　　ruddy (形) 紅潤的、變紅的
combustion (名) 燃燒　　ventilated (形) 空氣流通的、通風的

Sherlock Holmes Cool Science Magic Trick
The Coin that Doesn't Drop Down!

The key element in solving our case this time was a banknote.

Writing on banknotes isn't a good habit at all. Why don't we use a banknote to play a magic trick instead?

Get a new, crisp banknote and a coin.

Fold the banknote in half then stand it on one of its long edges with the crease at a right angle. Place the coin on top of the right angle.

Now straighten the banknote by gently pulling the sides. Look! The coin stays on the edge and doesn't drop down!

Unfolding the Scientific Mystery

Usually, it is very difficult to balance a coin on top of the edge of a standing banknote, so how come the coin in this trick does not drop down? This is because even though the banknote appears to have been pulled straight, a very small angle is still there at the crease. It is this small angle at the crease that is supporting the coin. More importantly, as we pull the banknote straight, the friction created between the edge of the banknote and the coin causes the coin to move and reposition itself to its new balancing point. This is why the coin does not drop down.

THE GREAT DETECTIVE
SHERLOCK HOLMES
— THE DYING DETECTIVE — ⑭

Original Story – Sir Arthur Conan Doyle
(This book is adapted from the story *The Adventure of the Dying Detective*.)

Adapter and Producer – Lai Ho

English Translator – Maria Kan

English Editor – Monica Leong

Illustrator – Yu Yuen Wong

Annotator – Lynn Hall

Cover Design – Chan Yuk Lung, Yip Shing Chi

Content Design – Mak Kwok Lung

Editors – Chan Ping Kwan, Kwok Tin Bo, So Wai Yee, Wong Suk Yee

> **f** 大偵探福爾摩斯
> For the latest news on
> ***The Great Detective Sherlock Holmes***
> or to leave us your thoughts and comments,
> please come to our Facebook page at
> www.facebook.com/great.holmes

First published in Hong Kong in 2020 by
Rightman Publishing Limited
2A, Cheung Lee Industrial Building, 9 Cheung Lee Street, Chai Wan, Hong Kong

Text : © Lui Hok Cheung
Copyright © 2020 by Rightman Publishing Ltd. All rights reserved.

Printed and bound by
Rainbow Printings Limited
3-4 Floor, 26-28 Tai Yau Street, San Po Kong, Kowloon, Hong Kong

Distributed by
Tung Tak Newspaper & Magazine Agency Co., Ltd.
Ground Floor, Yeung Yiu Chung No.5 Industrial Building, 34 Tai Yip Street, Kwun Tong, Kowloon, Hong Kong
Tel: (852) 3551-3388 Fax: (852) 3551- 3300

ISBN:978-988-8504-19-0
HK$68 / NT$340

> If damages or missing pages of the book are found, please contact us by calling (852) 2515-8787.

Online purchasing is easy and convenient.
Free delivery in Hong Kong for one purchase above HK$100.
For details, please visit www.rightman.net.

《大偵探福爾摩斯》
四字成語 101
看大偵探福爾摩斯，學習四字成語好輕鬆！

〔遍體鱗傷〕

身上的傷痕像魚鱗般密密麻麻，形容受傷慘重。

〔化險為夷〕

化難關為平地，比喻轉危為安。

每本收錄 101 個成語，
配合小遊戲和豐富例句，
提高閱讀及寫作能力！

《大偵探福爾摩斯》
英文填字遊戲

寓學習於遊戲！

- 以有趣的填字遊戲學習英文生字。
- 分「熱身」、「過渡」及「挑戰」三階段，由淺入深。
- 每個考驗附有「實用小錦囊」，介紹生字相關文法知識、中英對照例句及西方文化。